THE WONDERLAND PRESS

The Essential™ is a trademark
of The Wonderland Press, New York
The Essential™ series has been created by The Wonderland Press

Series Producer: John Campbell
Series Editor: Harriet Whelchel
Project Manager: Adrienne Moucheraud
Series Design: The Wonderland Press

Library of Congress Card Number: 99-73512
ISBN 0-8109-5814-7

On the endpapers:
Detail from *The Loge*. 1882. National Gallery, Washington, D.C.

Unless caption notes otherwise, works are oil on canvas

Printed in Hong Kong

Harry N. Abrams, Inc.
100 Fifth Avenue
New York, NY 10011
www.abramsbooks.com

Contents

Break the rules!

"Lions and tigers and bears, oh my! Lions and tigers and bears, oh my!"

Wait a minute: This is Mary Cassatt, not *The Wizard of Oz*. Let's try again: "Mothers and teacups and kids, oh my! Mothers and teacups and kids, oh my!" That's better.

Some people love the work of the expatriate American Impressionist painter **Mary Cassatt** (1844–1926), while others don't even know her name. Or they've heard of her but don't know why. Her images of mothers and children and tea parties may seem trite or profound to you, depending on your life experience. But no matter what you think of Cassatt, a waltz through her paintings and life will show you why this remarkable woman is ranked among the great American artists of all time. Despite its subject matter, since it evolved as Cassatt matured, her art evokes a profoundly modern spirituality and offers a ringside view of the fascinating Victorian era in which she lived.

One smart lady

Who was this renowned painter of mothers and babies and teacups? And how did she make her mark on the numbingly male-dominated world?

- Although she was born into a **conservative, upper-middle-class** Philadelphia family, the feisty Cassatt was **impatient with rules** and eager to **set her own agenda.**

OPPOSITE
*Ellen Mary
Cassatt in a
White Coat*
c. 1896
33 1/4 x 24 3/4"
(81.3 x 60.3 cm)

- She knew by the age of 15 that **she wanted to be a great artist,** and never backed down from the obstacles faced by women of her time.

- She was **ambitious**, lively, determined, and gifted, but also **practical** and focused and **did not suffer fools** gladly.

- Her enormous talents allowed her to work within a **wide range of mediums**: oil paintings, pastels, etchings, aquatints, and even a massive wall mural.

Cassatt decided to become a painter at a time when *young ladies* did not go off to art school and hire nude models to pose. If she offended social conventions, too bad. It was worth the risk, given her yearning for a life of artistic freedom and reward. She came from a well-to-do family and was born in the Victorian age of rigid conventions and prejudices against women. Yet the young girl from Pittsburgh followed her instincts and eventually traveled to Paris, where she became a friend of the Impressionist painters who were causing a rage in the art world of their time: **Édouard Manet** (1832–1883), **Claude Monet** (1840–1926), **Edgar Degas** (1834–1917), and **Alfred Sisley** (1839–1899). She showed paintings alongside theirs in Paris and New York, and sold her work to support herself. She became one of the best known and most beloved American painters of any time, and in the following pages you will see why Mary Cassatt is considered an icon in the history of American art.

Self-Portrait
c. 1880
Watercolor
on ivory wove
paper, 13 ½ x 10"
(33 x 24 cm)

There's something about Mary

Flashback: It was Paris in the mid-1870s. A young woman stopped before a gallery window. She was not a conventionally pretty woman, but there was something unique about her. Maybe it was the way she was squishing her nose against the window, as if devouring everything with her fiercely intelligent, gray-eyed gaze. What *was* she looking at so intently?

The object of her attention was a painting of ballerinas by artist Edgar Degas. The image was so exuberant it seemed to be dancing itself—capturing in soft, velvety pastels the rustle of crinolines, the fleet beat of feet, and the light illuminating the image.

But the woman saw something else in the window: the future, *her* future. She was Mary Cassatt, scarcely 30 years old, and would become famous for her riveting glimpses into women's private lives as well as her tender domestic scenes. Shortly after her encounter with this picture, Degas would invite Cassatt to exhibit with him and other rebel artists engaged in a bold, exciting new style of painting that became known as **Impressionism.** She would be:

- the **only American** ever invited to join the Impressionists, whose light-filled canvases caused a tizzy in the somber art world of 1870s' Paris;

- one of the few "girls" to belong to this boys' club;

- a **well-to-do, unmarried woman**, free to paint without worrying where her next meal would come from;

- an **independent** American in Paris, who gave teas, rode horses in the park, went to the theater, and hobnobbed with the great artists of her day;

- the **grande dame of American art**, in pearls and black feathers, who served as mentor to American art students and urged American collectors and museums to snatch up works by the Impressionists;

- **a passionate advocate of women's rights** whose courage continues to inspire feminists today.

The Wandering Years

And so the story goes: Mary Stevenson Cassatt was a woman of pluck—and luck. She was born in Pittsburgh, Pennsylvania, on May 22, 1844, into a prosperous family that gave her the emotional and financial support to be a professional artist.

Her father, **Robert Simpson Cassatt** (1806–1891), had inherited not just money but also the restless spirit of a family intent on venturing farther west in the state of Pennsylvania in search of opportunities. He moved the family around the state while dabbling in business, farming, and politics (he became mayor of Allegheny City, now part of Pittsburgh).

Her mother, the former **Katherine Kelso Johnston** (1816–1895), dutifully followed her husband, but had a mind of her own. She and Mary would share a close relationship over the years, and Mary would later immortalize her as an intelligent, vibrant, middle-aged woman in *Reading Le Figaro* (see page 44), a starkly beautiful oil painting done in grays, greens, mauves, and whites that showed Mrs. Cassatt in her apartment in Paris, pouring over *Le Figaro,* a leading French newspaper.

Mary was the fifth of seven Cassatt children. Her siblings were: **Katherine Kelso** (b. 1835); **Lydia Simpson** (1837–1882), who became

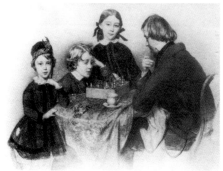

Robert Cassatt and his children: (*from left*) Gard, Robbie, Mary, and Robert Cassatt. 1854
Pencil drawing by Peter Baumgärtner

Archives of American Art, Smithsonian Institution

Mary's chaperone and closest confidante as well as her frequent model before dying young; **Alexander Johnston**, known as Aleck (1839–1906), the future president of the Pennsylvania Railroad; **Robert Kelso** (1842–1855), known as Robbie; **George Johnston** (born and died 1846); and **Joseph Gardner** (1849–1911), called Gardner or Gard.

Mary, Mary, wonderfully contrary

From the beginning, Mary was different from the pack. As the baby daughter of the family, she was something of a daddy's girl. Her father taught her to ride horses and affectionately called her "Mame" (pronounced Mamie), a popular nickname for "Mary."

The siblings closest to her in age died young: George died a few weeks after his birth, and the sickly Robbie died while the family was living

in Germany in 1855. This may have given Mary a sense that she was special, as well as an urgent desire to try to make up for her lost (male) siblings.

First trip abroad

When Mary was five, the family moved from Pittsburgh to Philadelphia. Then, in 1850, the family pulled up roots once again and moved to Europe. The Cassatts wanted to expose their children to a rich cultural life and decided that Paris was the place to be. They moved into a furnished apartment there and for two years lived in this exciting city, where art, literature, music, and a rich intellectual life ruled the day. For young Mary, it was a taste of exciting things to come and an introduction to the country that would later become her home.

Ja volt!

But Robbie was suffering from a debilitating bone disease, so Katherine and Robert moved the family to Germany in search of better medical treatment for their son. There was the added bonus of enrolling their son in a German boarding school that would prepare him for a career in engineering. For two years, they lived in

BACKTRACK:
AT HOME, BUT ABROAD

In the 19th century, it was not unusual for well-to-do Americans to visit Europe to enjoy its culture or to move there permanently. For the most part, these expatriates remained "definitely and frankly American," as Cassatt described herself. They stuck close to family, friends, and other Americans, about whom they read in newspapers like the *American Register*. Prominent American expatriates included the writers **Henry James** (1843–1916) and **Edith Wharton** (1862–1917), and the painters **John Singer Sargent** (1856–1925) and **James Abbott McNeill Whistler** (1834–1903).

Heidelberg and Darmstadt, then moved back to Pennsylvania in 1855, where they divided their time between Philadelphia and a country house in West Chester.

Come on already!

In 1860, Mary began her art training in earnest at age 16 by enrolling at the prestigious Pennsylvania Academy of the Fine Arts in Philadelphia, where one of her classmates was future artist and infamous Academy head **Thomas Eakins** (1844–1916). The Academy was the kind of place where students often toiled away in a dank basement, but it was also one of the finest, most progressive art schools in the country and among the first to train female artists.

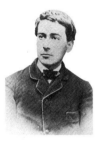

Thomas Eakins
1866

Yet prejudice was strong, and women were not allowed to attend life-drawing classes for fear that the sight of the undraped female figure—or, God forbid, of nude male models—might offend their delicate feminine sensibilities. Mary was undeterred by these limitations and

FYI: Copying the great works has always been an integral part of an artist's education. The notebooks of 20th-century American artist **Jackson Pollock**, the Abstract Expressionist, are filled with sketches of figures from the works of artists like Michelangelo and El Greco.

took advantage of Academy opportunities to copy every work of art in its collection, from ancient to contemporary paintings.

Cassatt attended the Academy for two years, but in 1863 decided it was time to study art on her own, free of the restrictions placed on her by the school's rigid curriculum. Though she remained casually in contact with the Academy until 1865, she lived with her family and indulged in her own creative pursuits.

By late 1865 or early 1866, it was clear that she needed to jump-start her training with a move to Paris, the art capital of the world. She had exhausted all other avenues of learning in Philadelphia and knew that it was time to immerse herself in the continent's artistic riches.

Mary Cassatt
c. 1863

Cassatt's father responded in the time-honored manner of a dignified, dictatorial Victorian dad: "I would almost rather see you dead than become an artist." Chilling words, but understandable within the context of the times: It was considered unusual, even morally repugnant, for a woman to be an artist or to have a career in the Victorian era.

Thanks, Dad!

But Mary was determined to be "someone and not something" and her father turned out to be a strong ally. He had always found Mary to be brainy, ambitious, and talented—as revealed in his letters to other family members, particularly to his oldest son, Alexander. What's more,

TOP
Alexander J.
Cassatt
c. 1856

BOTTOM
Eliza
Haldemann
1867

Mary was his favorite. Not only did Cassatt's father ultimately approve her move to Europe—accompanied by her mother and her classmate **Eliza Haldeman**—but he continued to support her financially as long as he lived. He asked only that she pay for her studio from her own earnings, once she began to make sales.

So, in the spring of 1866, Cassatt returned to Paris. It was the end of the Civil War and this was the artist's second trip to the continent. The major obstacle facing her was the male chauvinism of the art world: Not only were women not accepted as students at the prestigious **École des Beaux-Arts** (Academy of Fine Arts), the major training school for artists in France, but they were shunned in the professional art world, which was controlled by the dictatorial members of the Academy.

The dreaded Academy

Art was big business in France and opportunities for commercial success in that world were carefully controlled by the members of the Academy, who lived and died by a strict code of rules governing the kind of art they deemed to be in good taste and worthy of their approval. A large measure of their power came from the annual **Salon**, the major art exhibition that they sponsored for wealthy art collectors, high-profile critics, dealers, and VIP's of the art world. In order to be featured in the Salon, an artist had to submit his or her works to a jury of Academy members and be accepted by them. By nature conserva-

tive and defenders of "good taste" and the status quo, the members favored tried-and-true painters who upheld the Academy's rigid (and subjective) standards for art. They sanctioned highly polished history painting, mythological allegories that featured nubile beauties, heroic military scenes, poised scenes from the Bible, and somber portraits. Laughably, most of the artists sanctioned by the Academy are unknown today (their favorite was **Evariste Luminais**, 1822–1896), whereas many of the more innovative, creative ones whose works were summarily rejected by offended Academists went on to become the famous artists we continue to admire today.

The Academy frowned on innovation or change. They liked dark, somber canvases that treated serious subjects in detailed, classically formal ways, with refined brushwork and a restrained use of light. As a result, the younger, more daring artists had little chance for acceptance by this "good ole' boys" club unless they conformed to the strict style and choice of subject matter condoned by the Academy.

"I will not back down"

Since she was unable to apply for admission to the Academy, Cassatt decided to create her own plan for navigating through the chauvinist environment. She sought out two prominent teachers, the great figure painter **Jean-Léon Gérôme** (1824–1904), a faculty member at the Academy who happened to be the French artist most admired by

Americans in the 19th century, and the artist **Charles Chaplin** (1825–1891), no relation to the silent film star of the same name. Gérôme specialized in exotic, classical subjects and exquisitely molded nudes, such as those we see in *Young Greeks with Fighting Cocks.* True to the chauvinistic times, he was no fan of women artists, so it was a big triumph for Cassatt to be admitted to his private classes. This coup prompted her friends back home in America to write to Thomas Eakins—Mary's former classmate at the Pennsylvania Academy who was also a student

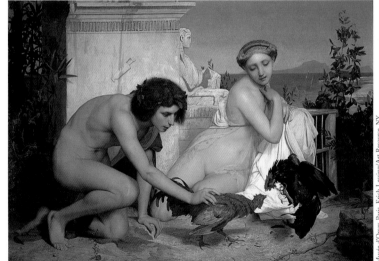

Jean-Léon Gérôme *Young Greeks with Fighting Cocks.* 1846 58.4 x 83.3" (143 x 204 cm)

Musée d'Orsay, Paris. Erich Lessing/Art Resource, NY

of Gérôme's in Paris—to prod for details. No doubt Gérôme was drawn to Cassatt's intelligence, talent, and discipline, but it didn't hurt that she came from a good Philadelphia family.

The Frenchman advised his students to examine art of every kind. Cassatt continued the practice she had begun in Philadelphia of copying masterpieces, only now she had the good fortune of doing so at the Louvre museum, having obtained a special permit granted to art students. There, she was joined by many other young women who also had been denied access to the École.

Looking for adventure

By 1867, Cassatt began taking trips with Eliza Haldeman to the countryside outside of Paris and to observe artistic styles being practiced by artists in small towns. In Écouen, she met **Édouard Frère** (1819–1886) and **Paul Soyer** (1823–1903), celebrated for their *genre paintings* (i.e., works in which the subject matter consisted of scenes from daily life). Cassatt was fascinated by the simplicity and honesty of these canvases, and was eager to try her hand at them. As opposed to *portraiture*,

BACKTRACK:
CASSATT AND EAKINS

Thomas Eakins was not only a classmate of Cassatt's, but was also a friend. They were both devoted to the study of the nude and he believed passionately that women and men should have equal opportunities in their studies and in life. For a time, the two young artists were on parallel tracks. Ultimately, however, their careers took different turns as Cassatt stayed in Paris and threw her lot in with the Impressionists and Eakins came home to America, developing a more realistic painting style and becoming a controversial educator at the Pennsylvania Academy of the Fine Arts, where he clashed with board members over his decision to let women students attend drawing classes where nude male models were present. Today, he is celebrated for the penetrating psychology of his figurative paintings, such as *The Gross Clinic* (1875).

ABOVE
Mary Cassatt
c. 1867

which presents specific individuals, genre paintings depict universal types, the Everyman.

In 1868, Cassatt scored an early success when the Salon—to her great surprise and delight—accepted one of her genre paintings, *A Mandolin Player,* a brooding image painted in a style that Cassatt would soon abandon. The work was important for two reasons:

- It shows a young girl actively *doing* something—in this case, playing an instrument as she looks off into the distance—instead of being painted merely as an object to be viewed. The subject does not make eye contact with the viewer; it's as if she consciously chooses her own world over that of people looking at her. The male domination of the art world is irrelevant to her. The treatment of this young woman is rather staid, but Cassatt's choice of a self-assured woman will remain constant for the rest of her career. The mandolin player stands shoulder-to-shoulder with her singularly self-possessed sisters—the intriguing women of later Cassatt portraits and figure paintings.

OPPOSITE
Detail from
Mandolin Player
1868. 37 ½ x 30"
(92 x 73.5 cm)
Private collection

- Cassatt signed the *Mandolin Player* "Mary Stevenson"—using her first and middle names only—so as not to call attention to herself, a single young American woman living abroad. (On the other hand, she convinced an American critic living in Paris that he should mention her painting in his review for *The New York Times*, which he did most pleasantly.)

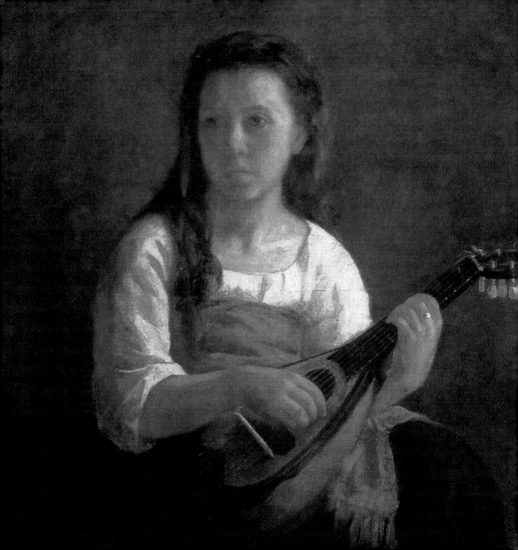

Living dangerously

Just as her life was taking off in Paris, things fell apart. The Franco-Prussian War forced Cassatt and her mother to abandon France for the safety of America in August of 1870, after a detour to Rome for the summer.

Back in Pennsylvania, she sent two paintings to the New York branch of the art dealer Goupil and Co. (the firm where Vincent van Gogh's brother, Theo, would later work as a successful dealer), but collectors didn't bite. Hoping for better luck in Chicago, Cassatt set out for the windy city with two paintings in tow, but they were destroyed, along with many other canvases, in the Great Chicago Fire of 1871.

Viva l'Italia!

Before long, Cassatt got her next break. Bishop Michael Domenec, the Roman Catholic bishop of Pittsburgh, offered her $300 to go to Parma, Italy, to copy two works by Italian Renaissance artist **Antonio Allegri da Correggio** (c. 1489–1534), *Coronation of the Virgin* (1520–30) and *Madonna of Saint Jerome* (1527–28), for the new Saint Paul's

Galleria Nazionale, Parma. Scala/Art Resource, NY

Cathedral in Pittsburgh. This theme of the Madonna and Christ Child would influence Cassatt's later works, as she transformed the religious characters into the more general subject of mothers and their children.

Parma was the opportunity Cassatt had been waiting for. It was her means of returning to Europe, and she jumped at the chance. Her friend from Philadelphia, the 30-year-old **Emily Sartrain,** accompanied her to Italy, where they would spend eight happy months in Parma. Emily was already a successful engraver working in the engraving firm of her father, **John Sartrain**, a leader of the Pennsylvania Academy and a major figure in American art education.

Printing with Carlo

In the overall scheme of things, the Pittsburgh commission per se turned out to be less important than the opportunities it provided. While in Parma, Cassatt steeped herself in the work of the much-copied, much-admired Correggio, acclaimed for his complex arrangement of figures. Her work in this period reflected a kind of idealism, and when she completed her replica of the *Coronation of the Virgin* (now lost), Bishop Domenec sang her praises. (For reasons unknown, she did not finish the *Madonna of Saint Jerome.*)

The big opportunity, however, came when she met the talented **Carlo Raimondi** (1809–1883), head of the engraving program at Parma's Academy. She would study printmaking with Raimondi and he would soon become a valued, attentive mentor who opened important doors for her. Not only was this period a great stretch for her as an artist, but it was a vital stepping-stone in her process of building a network of influential contacts.

While in Italy, she created two paintings that soon met with success—*Two Women Throwing Flowers During Carnival*, accepted by the Paris Salon, and *Bacchante* (see page 24), accepted by the Exposition of Fine Arts in Milan. In *During Carnival*—which Cassatt would later exhibit in Philadelphia and for which a collector would shell out $200 (a vast sum then)—a pair of Italian flirts toss flowers from a balcony during Mardi Gras, one suspects to a pair of handsome young men below.

In *Bacchante,* Cassatt shows an ecstatic follower of Bacchus, the Roman god of wine, caught in mid-whirl, with eyes and cymbals flashing. Note Cassatt's use of the exotic costume to bring character and local color to this genre painting, even if it is stylized and somewhat idealistic.

Both works reflect a continued use of dark colors and female subjects engaged in activities other than staring out at the viewer, waiting to be admired. From the beginning, Cassatt's women had a sense of purpose and focus, as did the artist.

Olé, Señorita!

In the fall of 1872, Cassatt fulfilled a long-held dream and traveled to Spain, spending a few weeks in Madrid, where she copied works at the Prado museum by some of Spain's greatest artists, including **El Greco** (1541–1614), **Francisco Goya** (1746–1828), and especially **Diego Velázquez** (1599–1660), whose style she pronounced "fine and simple." She was thrilled by the realism in Velázquez's 1656 painting *Las Meninas* (*The Maids of Honor*), in which the true subject is not the Spanish heiress, the Infanta Margarita, or her dwarf attendants, or the artist himself—all brilliantly realized—but the two

Carte-de-visite photograph of Mary Cassatt taken in Parma. 1872

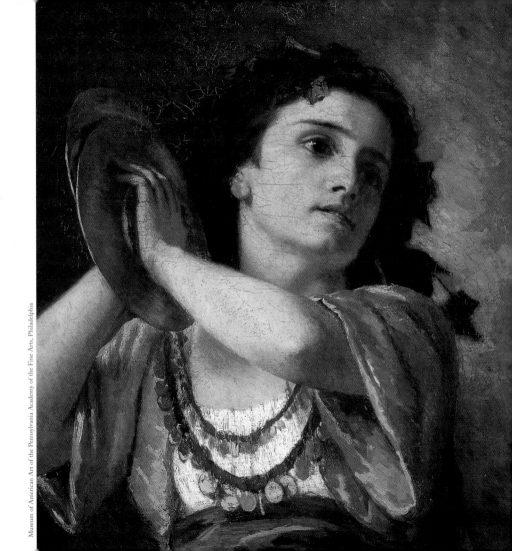

figures reflected in the small mirror in the upper left-hand corner, King Philip IV of Spain and his wife, Queen Mariana. The king and queen have just walked in on their daughter, her attendants, and the artist, who is hard at work at his easel. The viewer witnesses the scene from the same vantage point as the kind and queen. We see what they saw as they entered the room.

OPPOSITE
Bacchante. 1872
25 x 21"
(62 x 50.7 cm)

LEFT
Diego Velázquez
Las Meninas. 1656
10'5" x 9' 1/2"
(3.18 x 2.76 m)

The testosterone factor

OPPOSITE
Toreador
(aka *After the*
Bullfight). 1873
33 ½ x 26"
(82 x 64 cm)

A few weeks later, Cassatt headed south to Seville, where she indulged in more genre paintings and scenes depicting the archetypal Spanish hero: the *toreador*, or bullfighter. For the first time, Cassatt used adult males in her works, influenced perhaps by the energy of Spain's macho culture—with all those bullfighters in tight pants—and by the ready availability of models. (An earlier portrait of her father was never completed.)

In *Toreador* (aka *After the Bullfight*), a bullfighter lights up a cigarette, presumably after a successful round of goring and maiming bulls. He exudes a relaxed self-confidence and a kind of swarthy masculinity that one often associates with the sensuality of bullfighting. Cassatt's Spanish paintings reflect a darker, more somber palette and the use of thicker paint than one sees in her previous works.

People often wonder why Cassatt didn't paint men more often. Was it because she was a lesbian? No. Sex played all but no role in her life. Was it because she lacked training in drawing the male anatomy? This seems unlikely, since the sexy and broad-shouldered bullfighter doesn't seem the worse for it. Was it a lack of access to male models in America and France? (At one point, she grumbled that all the good models went to male artists!) Or was it because it would have been inappropriate for a young female artist to be alone in a studio with a male model during these repressive Victorian times?

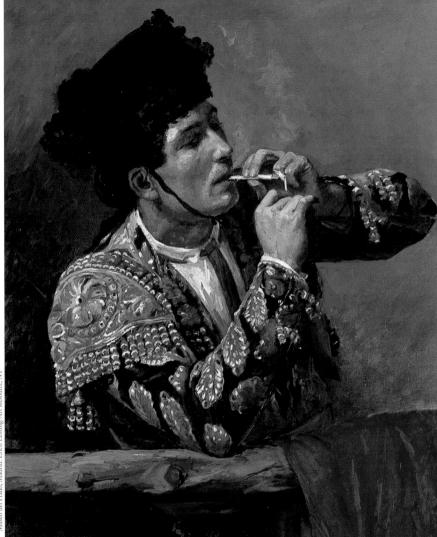

Who knows, but whatever the reasons, Cassatt returned only rarely to the male figure, in works such as:

- A pensive portrait of her brother Alexander (see page 57) in which a detailed depiction of his fair features contrasts sharply with the furious dark brush strokes of his suit and the almost hasty brush strokes of the unfinished green backdrop.

- A tender study of Alexander and his son, Robert Kelso (see page 72), in which Cassatt lovingly conveys the deep bond between father and child by failing to delineate where the dark suit of one leaves off and the other begins.

- *The Boating Party*, a much-esteemed work from 1893–94 in which a man, woman, and child row together (see pages 92–93).

Pushing ahead

Cassatt was on a roll, professionally. She remained in Spain from 1872 through 1874, and created enough paintings to keep her stocked with entries to exhibitions in France and America for several years to come. And yet, something was missing. She found Seville dull. So, in April 1873, Cassatt hopped a train for Paris, where she reunited with her mother and Emily, who had returned there directly from Parma.

Bright Lights, Big City

It was a great time to settle in Paris. The city had shaken off the dust of political turmoil to become the Paris that would later be immortalized by songwriters and filmmakers alike—the Paris of broad boulevards and grand gardens. The people responsible for the rebirth were **Emperor Napoleon III** (1808–1873) and urban planner **Baron Georges Hausmann** (1809–1891). Paris was a playground for all. And while Cassatt painted eight to ten hours a day—often refusing to stop for visitors—she wanted to have fun, too.

There were things, of course, that 19th-century ladies couldn't do. For example, there is no documentation of Cassatt sitting in cafés, sipping absinthe and kicking up her heels with bawdy artists like **Henri de Toulouse-Lautrec** (1864–1901). Still, there were plenty of good times to be had by unmarried women of a certain means—such as driving in a horse-drawn carriage through the Bois de Boulogne, the lush forest on the western edge of Paris; or sweeping up the grand staircase of the new Paris Opera, where the brilliant limelight vied with the glittering jewels of patrons.

At the Salon of 1873, she exhibited *Torero and Young Girl* under the name Mary Stevenson-Cassatt, thus moving one step closer to claiming her identity as Mary Cassatt.

In June of that year, Cassatt took her mother to The Hague (in the Netherlands) and to Antwerp, Belgium, where she painted daily with her friend **Léon Tourny** and his wife, close friends of Edgar Degas.

Trouble brewing

Young artists had become louder in their rumblings about the stranglehold of the art establishment over artistic expression. Cassatt saw the problem, but was in a bind: She agreed with the rebel artists that the Academy's endorsement of prevailing styles inhibited new forms of creative expression, but she knew that if she wanted a commercially successful career, she must play by the Academy's rules, even if she felt cynical toward them.

In October, Cassatt returned to Paris to see her mother off to Philadelphia. A month later, she set out for Rome, but the old magic was gone. In early 1874, her painting *Ida,* a conventional portrait of a red-haired woman in a lace veil, was accepted for the Salon of 1874. However, she found Rome dull and longed for the energy of Paris, so in June Cassatt moved to Paris for good.

An important friendship

When Cassatt was 30, her timing was perfect and a number of opportunities opened up. Sartain introduced Cassatt to the 19-year-old **Louisine Elder** (1855–1929), future wife of sugar baron **Henry O.**

Havemeyer (1847–1907). Eleven years younger than Cassatt, Elder would become the artist's close confidante for decades to come: They shared a passion for art, and each valued the keen intelligence of the other. (Years later, the Havemeyers would rely on Cassatt to assist them in amassing one of America's most valuable art collections, which would subsequently be donated to The Metropolitan Museum of Art in New York. Louisine would also one day urge Cassatt to use her art to promote the cause of women's rights.)

Rebels with a cause: the Impressionists

Mary had become familiar with several of the artists who would soon become known as Impressionists. These experimental painters shared a passion for things modern and refused to go along with the demands of the Salon. They declared their independence from the jury system and saw themselves as the wave of the future, with their light-filled canvases, free-spirited brush strokes, and exuberant use of color. The mavericks formed an association called *La Société Anonyme des Artistes, Peintres, Sculpteurs, Graveurs* (the Independent Society of Artists, Painters, Sculptors, and Engravers) and rule numero uno was that members could not submit to the Salon. Even though the Impressionists were working within a wide range of art forms and styles, they were linked by their shared desire to create modern, unsentimental, spontaneous art that reflected a specific moment in time. They wanted to evoke nature and life in their large reality.

The charter members included Claude Monet, Edgar Degas, Alfred Sisley, Auguste Renoir, **Camille Pissarro** (1830–1903), **Berthe Morisot** (1841–1895), and five others. Their first exhibition—which coincided with the Salon of 1874—was held at the studio of a photographer named Nadar on the Boulevard des Capucines. It included 165 paintings by 29 artists. While Degas painted the human figure, Monet and Pissarro preferred landscapes, but the common denominator was that they painted reality as they saw it before them, not in a fantasized or idealistic way. Since oil paint was now available in lead tubes, artists were able to take their easels outdoors and paint in the sunlight. They focused on moments from daily life, with real people and real locations.

First Impressionist exhibition

The critics and members of the Academy, shocked by the works at this exhibition, protested that the artists appeared "to have declared war on beauty." On April 25, 1874, the critic Louis Leroy published a mock satirical conversation in *Le Charivari* entitled "Exhibition of the Impressionists." His intent was to scoff at the "impression of a rising sun" in Monet's painting *Impression, Sunrise*, but the name stuck and the group became known as the Impressionists.

This first exhibition seemed to be a failure, since the public laughed at the innovative works and the critics lambasted them.

French vs. American Impressionism

It was not long before American artists embraced Impressionism as well. The American Impressionists were a slightly younger group who got their start in the States in the 1880s. Key players included **William Merritt Chase** (1849–1916), **Childe Hassam** (1859–1935), and **John Twachtman** (1853–1902). Though Cassatt was an American and, at that time, an Impressionist, she belonged with the French group, because she worked and exhibited with its members in Paris.

The momentous 1874

It was around this time that Cassatt saw Degas' ballerinas in the shop window. Meanwhile, Degas' friend Léon Tourny, also a friend of Cassatt, introduced him to Cassatt's painting *Ida* while the men were wandering through the Salon of 1874 at the *Palais de l'Industrie*. Degas reputedly felt drawn to Cassatt upon seeing the canvas. (*Ida* is now lost and there are no photographs of it.) Thus, even before they met, Cassatt and Degas had a kind of "soul-mate" energy with one another.

Sound Byte:

> *"Here is someone who feels as I do."*
>
> —EDGAR DEGAS, 1874, upon seeing
> Mary Cassatt's painting *Ida*

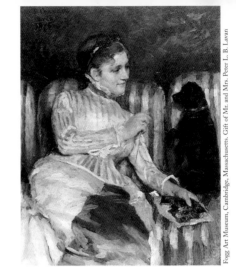

Young Woman on a Settee with Black Dog. 1875
Oil on panel
13 ¾ x 10 ½"
(33.7 x 25.7 cm)

Major decision

By 1875, Cassatt felt increasingly conflicted about her work. She sensed a growing need to experiment with color and form, yet feared offending the Academy. She continued to paint in genre, as she had in Parma, Seville, and Rome, but she ventured out in new directions with works that captured people in elaborate but modern costumes and in scenes of everyday life in their Parisian apartments, such as sewing, reading, and playing with their dogs. A fine example of her work from this period is *Young Woman on a Settee with Black Dog* from 1875, in which she used her own furniture as props and thereby personalized her work. The American market responded favorably to her paintings from this period and this enabled her to gain financial independence for the first

time. She shored up her domestic arrangements by finding both a studio and a home, since, by 1875, her sister Lydia—suffering from Bright's Disease, a fatal kidney ailment—had come to live with her. (Two years later, their parents would follow, having seen their sons grow up and become established in America; they would make Paris their retirement home.)

When one of her paintings was rejected by the Salon in 1875 for being too light-filled, the ever-feisty Cassatt decided to play a game: She darkened the painting and resubmitted it the next year. The Salon of 1876 accepted it! But in 1877, they rejected *Head of a Young Girl* (see next page) because they felt her brushwork was undisciplined and that (yet again) there was too much light on her canvas. That was the final straw.

Enough's enough!

Ironically, there is no record of Cassatt's first meeting with Degas, but one thing is certain: In the spring of 1877, Degas made her an offer she couldn't refuse—to join the Impressionists. (This fateful encounter may have taken place during a visit by Degas to her studio, with Tourny making the introductions.) Cassatt was ripe for change and decided to follow her instincts instead of stifling herself with attempts to please the Salon. No more rules, no more juries, and from now on she would never accept awards for her work. Until now, she had been a conventional artist, drawing on tried-and-true subjects and artistic approaches (e.g., exotic or elaborate costumes) that pleased the Academy.

Head of a Young Girl
c. 1876
Oil on panel
12 ³⁄₄ x 9"
(31.2 x 22 cm)

But it was time to break with the past. Once her mind was set, Cassatt became a strong disciple of Impressionism. She lightened her palette even further and indulged in painting the ever-fleeting moment, as can be seen in her *Self-Portrait* (on page 7) and in later works like *Summertime*. It was the beginning of a more independent career for her. Cassatt had reached the point where *she*—not a group of outsiders—would now call the shots.

Sound Byte:

"I accepted with joy that I had already recognized who were my true masters. I admired [the painters] *Manet, Courbet, and Degas. I despised conventional art. I began to live."*

—MARY CASSATT, 1912, on her decision
to join the Impressionists

FYI: How did Cassatt fit in with the French Impressionists?—
She was most friendly with Degas and Camille Pissarro, with whom she collaborated, and with Berthe Morisot, sister-in-law of Impressionist favorite Édouard Manet. But Cassatt's status as a well-to-do, unmarried American woman kept her from associating too closely with her struggling, mostly male colleagues and made her an object of envy. Mary Cassatt was one of the few women in the boys' club of French Impressionism. Another was **Eva Gonzalès** (1849–1883), a disciple of Manet.

Time out: Cassatt and Degas

In a way, Cassatt and Degas were Impressionism's Odd Couple—the fiercely independent Yank and the finicky Frenchman. She was an American of French-Irish descent; he was a French child of an American mother. Their decades-long relationship was intense and often explosive, but ultimately gratifying. Their liaison continues to fascinate us today as much for what is *not* known about it as for what *is*.

Edgar Degas
c. 1885

Degas, like other Impressionists, rightly believed that Cassatt could help introduce their art to the American market. In addition to sharing a hunger for commercial success, the two revered and studied the art of the past. Both loved bright pastel colors and refused to sentimentalize the people in their paintings. Both made their mark in various media—in oil paintings, sensuous pastels, and exacting prints. In 1879, they made plans for starting a journal, *Le Jour et la nuit* (*Day and Night*), that would feature their black-and-white etchings. But it never got off the ground, apparently because Degas was unable to complete his own prints for the publication in time. One etching, *Mary Cassatt at the Louvre: The Etruscan Gallery*, shows Mary examining an antique sculpture as Lydia flips through a guide book.

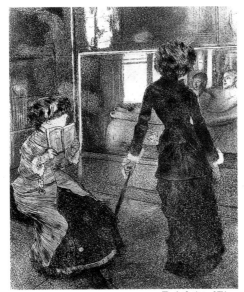

LEFT
Edgar Degas
*Mary Cassatt at
the Louvre: The
Etruscan Gallery*
c. 1879. Softground
etching, drypoint
and aquatint
printed in black
on laid paper
10 ½ x 9 ⅛"
(27 x 23 cm)

OVERLEAF
*Little Girl in a
Blue Armchair*
(aka *Portrait of a
Little Girl*)
1878. 36.5 x 53"
(89.5 x 129.8 cm)

Cassatt rode horses. Degas painted them. She adored nudes. He was a master of them. She loved capturing the theater's glittering audiences. He preferred the shadowy world beyond the footlights.

Was he her mentor, as some have suggested? She did her first nudes— a series of etchings—under his supervision, and he offered her advice about the play of light through curtains, as seen in her saucy and naturalistic *Little Girl in a Blue Armchair*, with its great details of costume

39

and setting. He was even known to con-tribute to her paintings, including *Little Girl.*

What brought them together might also have led to what Louisine Havemeyer called their "spicy estrangements." Cassatt and Degas were people of passion, pride, and, unfortunately, prejudice. (Much has been made in recent years of their anti-Semitism. They displayed a prejudice toward Jews and minorities that was, alas, typical of their time. But it did not stop them from befriending Jews, including their *Day and Night* collaborator, the fatherly Camille Pissarro.)

Given their temperaments—and knife-twisting wit—it's no wonder they were often at odds. Case in point: Cassatt championed the cause of the French-Jewish Army officer **Alfred Dreyfus** (1859–1935), who had been wrongly accused by the French government of selling military secrets to Germany.

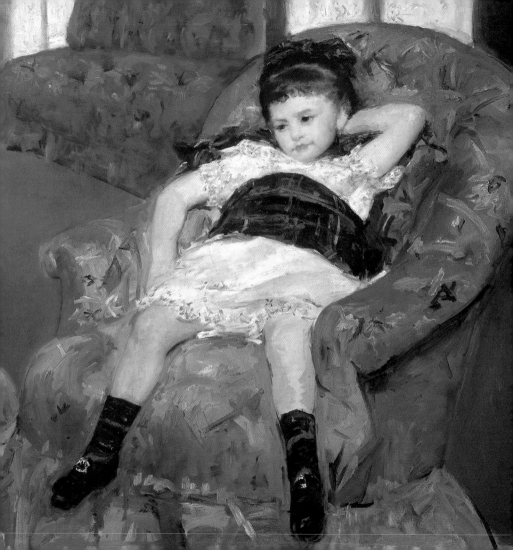

Degas sided with the government. Dreyfus was convicted of treason during the infamous "Dreyfus Affair" of 1894, but in 1906, the Court of Appeals cleared him of all charges.

Were Cassatt and Degas lovers? Probably not. There is no evidence to suggest that they were anything more than dear friends and mutually respecting colleagues. Both, it seems, were too set in their ways and too proper to indulge in a sexual relationship. And yet, witness the sensual manner in which Degas portrays Cassatt, commanding and confident, in his pastel *At the Milliner's* (see page 49), where she tries on a hat. Or the casual way he catches her leaning toward him—and us—in his portrait *Mary Cassatt*, which dates from around 1880–84 and in which she holds *cartes-de-visite* (popular 19th-century calling cards containing photographs of the bearer) in her hands, like a gypsy telling a fortune. Cassatt called the painting "repugnant" and later quietly put it up for sale. But was it repugnant to her because she didn't look prim and pretty—or because it assumes a highly intimate familiarity between artist and subject that she did not want revealed?

Whatever the nature of their "friendship," Cassatt and Degas took it to their graves. He saved no letters, and she destroyed all his letters to her.

Back to April 1877

The Third Impressionist Exhibition was taking place at the time Cassatt accepted Degas' invitation to join the Impressionists. She real-

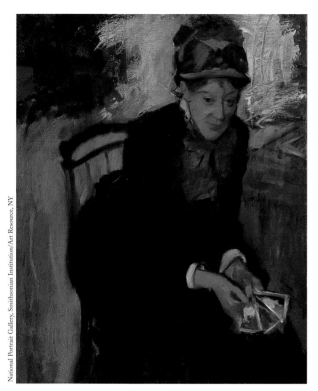

Edgar Degas
Portrait of Mary Cassatt (aka *Mary Cassatt Seated Holding Cards*)
c. 1880–84
30 ¼ x 24 ½"
(74 x 60 cm)

ized that there was little time to lose in preparing for the next year's exhibition. But as luck would have it, she didn't need to worry, since the exhibition of 1878 was cancelled so as not to compete with the World's Fair.

Mary now set about painting friends, family, and everyday situations. She portrayed her mother with a newspaper in *Reading Le Figaro* and created an intriguing gouache, *Portrait of the Artist* (1878), one of her few self-portraits. **These works were less studied and more sponta-**

RIGHT
Reading Le Figaro
c. 1878
39 ¾ x 32"
(97.4 x 78.4 cm)

FAR RIGHT
Portrait of the Artist (aka *Self-Portrait*)
1878. Gouache on paper. 24 x 18"
(59.7 x 44.5 cm)

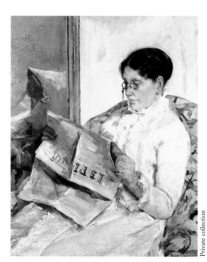

Private collection

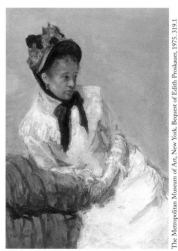

The Metropolitan Museum of Art, New York. Bequest of Edith Proskauer, 1975. 319.1

neous than her previous paintings and reflected the Impressionist interest in viewing unposed people and situations—the "slice of life" quality. She softened the vertical lines of the striped fabrics in the earlier works into curved lines and rounded shoulders in works such as *Lydia Leaning on Her Arms, Seated in a Loge* (see page 54).

By the time of the Fourth Impressionist Exhibition, on April 10, 1879, Cassatt had 12 paintings ready to show. Despite continued grumblings by the press, the show was a big success and Mary felt optimistic about her chances for recognition. Her mood was buoyant and it was the beginning of her eight-year Impressionist period (1879–86). The year 1879 was also the time when the prominent Parisian art dealer **Paul Durand-Ruel** (1831–1922) began to represent Cassatt's works. He would later represent her at his gallery in New York as well.

Paul Durand-Ruel
c. 1890

Seeing and being seen

Theater and opera inspired much of Cassatt's best work of this period and was yet another interest she shared with Degas. But while Degas was intrigued by the goings-on backstage, Cassatt was busy observing the audience, particularly its female members.

Other artists portrayed women at the theater as beautiful objects to behold, but Cassatt would have none of this. Her women looked sensational, to be sure, but she painted them so that **they projected a desire to be appreciated for being more than mere objects** to behold.

They wanted to *look*, too, and to take in their surroundings. It is hard to imagine Cassatt—the feminist who thought a woman should be "someone and not something"—portraying her subjects in any other manner, as we see in two important works, *At the Opera* and *Woman in a Loge*.

Theater and opera

OPPOSITE
At the Opera (aka
At the Français)
1877–78. 32 x 26"
(78.4 x 63.7 cm)

One of Cassatt's most significant early paintings and one of her most psychologically penetrating works, *At the Opera* depicts a curious moment of seeing and being seen at a performance. The painting shows a woman looking out through her opera glasses from the loge (i.e., the mezzanine balcony just above the boxes). From the slightly upward tilt of her opera glasses, we see that she is looking not at the stage but at something—or someone—across from her, perhaps in the opposite loge. At the same time, a man seated a few stalls away, in the curving loge, is training his opera glasses on her. Even though we cannot see his face and hands distinctly—indeed all of the figures in the background stalls are blurred—we know that this is what he is doing. Not only is he observing the woman with the opera glasses, but since we are looking at her *and* him, he is also watching *us*. This may be unnerving to the viewer but not to the woman who is the subject of this painting. She continues to keep her eye on the prize, so to speak. Her mouth is set. Her gaze and hand are steady. She is undeterred. **She is an archetypally strong Cassatt woman**.

Cassatt plays with shifting viewpoints by drawing our attention to a woman in the foreground who looks out to the left of the canvas, and

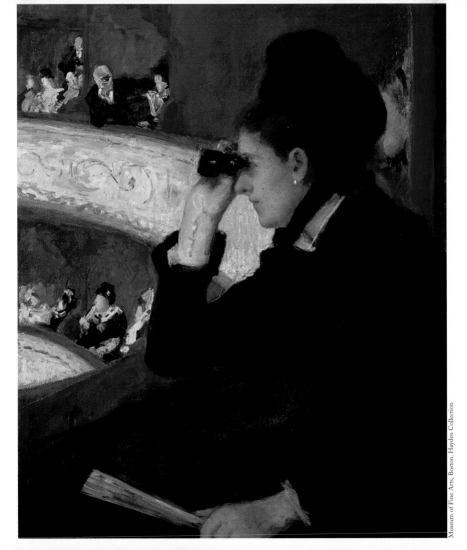

to a man in the background looking straight out at the woman and at us. In this sense, **the painting is a masterpiece of perspective**. At the same time, Cassatt comments on the eternal balancing act of womanhood—the notion of being on display even when you do not wish to be on display, and yet also relishing the right to display yourself. The solution Cassatt proposes is to keep your eyes focused on what you want. Only then does it not matter where others are focusing their eyes.

Cassatt lavishes attention on the woman's face and form, right down to her stud earrings and lacy cuffs, yet she dismisses the background figures with a few quick brush strokes. Her goal is to convey the act of concentrating on one thing and of taking in the rest hurriedly. This **photographic technique** is typical of the Impressionist style that Cassatt embraced in the 1870s and that she developed through the use of a sketchbook, which she took everywhere. Degas used the photographic technique, too, in works such as *At the Milliner's*, in which the companion's face is turned away from the viewer, as if Degas is saying that you don't have to notice everything. By the way, the woman trying on the hats is quite probably Cassatt.

FYI: The French critics of Cassatt's day tended to describe her work in masculine terms, as being strong and solid, while they described Berthe Morisot's paintings in feminine terms, as airy and delicate.

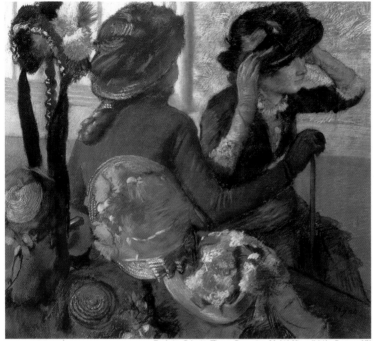

Edgar Degas
At the Milliner's
c. 1883
29 ⁷/₈ x 33 ³/₈"
(75.9 x 84.8 cm)

Go, girl!

In *Woman in a Loge*—one of the paintings Cassatt sold during the Fourth Impressionist Exhibition—the flame-haired subject has to know she looks marvelous in an off-the-shoulder, peachy-pink gown that catches

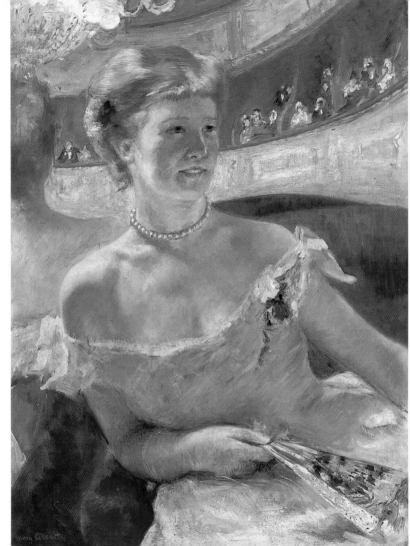

and holds the light. She's practically biting her lower lip to contain her delight. (The woman may be Lydia, who often posed for Cassatt, or a Swedish model Cassatt sometimes used.)

Even though she may be aware that someone is looking at her—after all, *we* are looking at her—the woman pays no mind. Instead, she is busy looking at someone (or at something) outside the picture. But who? Perhaps the artist. Or maybe someone in one of the sweeping gold and crimson, chandelier-lit theater boxes reflected behind her.

Note that the woman in *At the Opera* is dressed differently from the one in *Woman in a Loge.* The woman in the former work is at a matinée, for which a low-cut gown and conspicuous jewelry would not be acceptable. Each woman has two accessories that would have been indispensable in the 19ᵗʰ century, day or night—gloves and a fan that could conceal her face and, thus, the direction of her gaze.

Mirror, mirror on the wall

In *Woman in a Loge,* Cassatt has fun with mirrors, lulling us into believing at first that the gold and crimson theater interior is the backdrop for her subject, when in fact it is the *reflection* of the theater's interior that is the background. Since the woman is facing the audience as well as us, **we are, in effect, part of the audience.** So we are, cleverly, in both the foreground and the background.

OPPOSITE
Woman in a Loge
1878–79
32 ³/₄ x 23 ³/₄"
(80.2 x 58.2 cm)

Cassatt, of course, is not the first artist to play with mirrors and perspective in her work. Her beloved Velázquez did a terrific job of this in *Las Meninas* (see page 25). And another Cassatt favorite, Manet, used a mirror to spectacular effect in *Bar at the Folies Bergères*. The dull expression of the waitress, who is serving the patron reflected in the upper right-hand corner, contrasts vividly with the brightly lit panorama of the theater, seen in the mirror behind the bar.

In *The Loge*, two women sit rigidly, as if waiting for something to happen on stage. They seem isolated from the audience, as if they are in the limelight, for all to see. In true Impressionist form, Cassatt floods

RIGHT
Edouard Manet
Bar at the Folies Bergères. 1881–82
37 ½ x 51"
(92 x 125 cm)

OPPOSITE
The Loge. 1882
31 ³/₈ x 25 ¹/₈"
(79.8 x 63.8 cm)

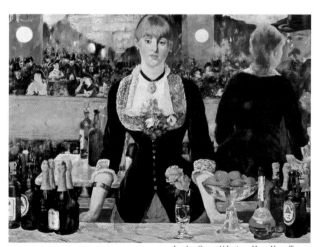

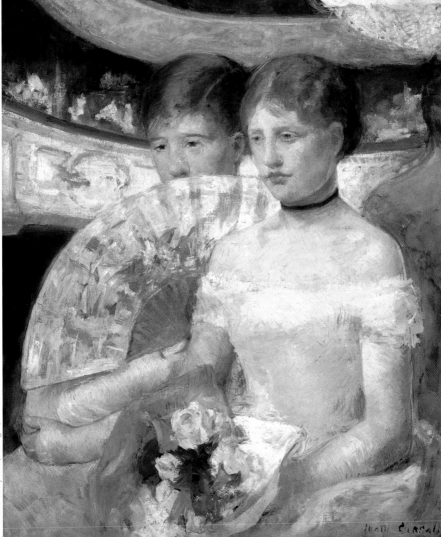

them with the glow of light. Gone are the relaxation and vibrance, however, that we see in the pastel *Lydia Leaning on Her Arms, Seated in a Loge*, from roughly the same time. The chandelier that lights the canvas reinforces the energy that emanates from Lydia, but there is no energy present in *The Loge*—merely a kind of stiffness.

OPPOSITE
Lydia Leaning on Her Arms, Seated in a Loge
1879. Pastel
21 5/8 x 17 3/4"
(53 x 43.5 cm)

Family affair

Since Cassatt was experiencing greater success in France than in America, she began to resent her own country's reluctance to embrace her work and gradually distanced herself from her American friends and contacts. France was her home now, and the artist's work—beginning with the scenes of theater and opera—reflected this French flavor.

Homebodies

As the 1880s began, Cassatt shifted her artistic focus from the exterior world of the theater to the interior one of home and family. There were practical reasons for this: Her parents were getting older, and Lydia, never particularly strong and healthy, had become sicker with Bright's Disease. Moreover, Cassatt's brother Aleck and his wife Lois and four children (Eddie, Katharine, Robbie, and Elsie) arrived for an extended visit, which would provide Cassatt with a ready supply of children as models. She took advantage of the occasion by **capturing**

her family in slices of everyday life. In the process, she created some of her most often reproduced images.

As with her theater scenes, Cassatt was not content to portray her family merely sitting idly for her. In Impressionist style, she froze fleeting moments, such as her mother reading a story to her grandchildren; and Lydia, always Lydia, reading, crocheting, presiding at tea, intently working at her embroidery frame.

Even when family members appear to be doing nothing, as in *Portrait of Alexander J. Cassatt*, they are still doing something—listening or thinking. They are slightly off-balance, as if ready at any moment to spring up, or they seem totally absorbed in a fascinating conversation that only they can hear. Their appearances are charged.

In fact, art historians wonder if these are portraits of real individuals or, rather, genre paintings in which Cassatt uses individuals to suggest types. The answer is that they are both. Cassatt's family portraits depict real people who can be identified, but the portraits are presented in such a way that they could also be grouped under such generic categories as *doting mothers, adorable children,* and *mysteriously elusive women.*

Aunt Mary

Cassatt was at a personal and professional crossroads. She was no longer the family's precocious baby girl or the spirited young woman

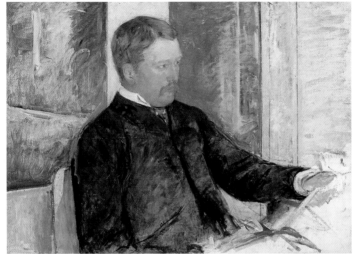

who had sailed off to Europe in search of a grand career, but was now, in mid-life, her failing parents' keeper. She had moved them to a series of increasingly comfortable Paris apartments and shuttled them to a variety of summer homes. (Robert Cassatt would die on December 9, 1891; Katherine, four years later, on October 21, 1895.)

Modern all the way

This interest in her family, expressed in a more somber fashion, can be seen in *Portrait of a Young Woman in Black* (aka *Portrait of Madame J.*

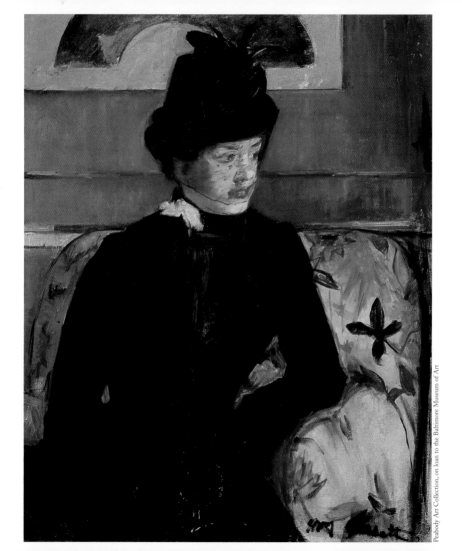

1879–80). The work is believed to be a portrait of Cassatt's sister-in-law Jennie (the wife of Gardner Cassatt) and casts Madame J. as the epitome of feminine mystique. Cassatt had developed a reputation as a successful portraitist, despite her reluctance to become known as such, and painted her sister-in-law in the simplest of terms, her porcelain skin and ruby lips—along with the white flower at her throat—contrasting vividly with her elegant black outfit. Though the clothes are strictly 19th century, the look remains surprisingly modern. The lush floral pattern of the overstuffed chair in the Cassatt drawing room—again very contemporary—makes Madame J. appear even more starkly beautiful.

The intensity of Madame J.'s gaze and the way she leans slightly forward make her vibrancy palpable. At the same time, it's hard to know what she's thinking. The faint play of a smile on her lips gives away nothing. She is as lovely—and as remote—as the *Mona Lisa.* Notice that the wall-hanging behind Madame J. is a mounted fan decorated with ballerinas, presumably by Degas.

Tea and sympathy

As she moved away from Impressionism, Cassatt was captivated by the domestic theme of afternoon tea, the popular 19th-century ritual that allowed ladies to catch up on the latest news and gossip.

OPPOSITE
Young Woman in Black (aka *Portrait of Madame J.*)
1879–80. 33 x 6 ½"
(80.6 x 64.6 cm)

OVERLEAF
Tea (aka *Five O'Clock Tea*)
1879–80
26 ½ x 38"
(64.7 x 92.7 cm)

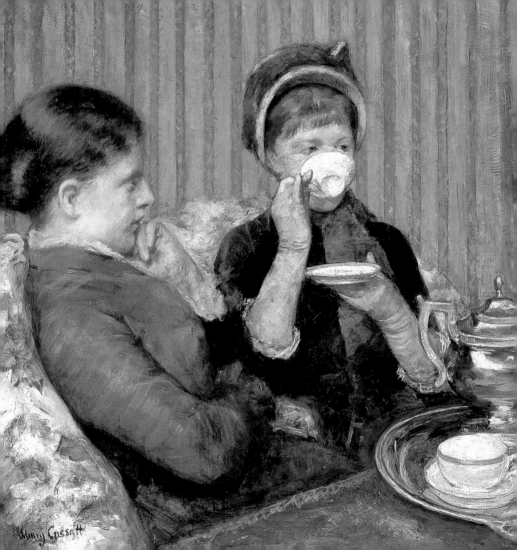

It was an organized and formal affair. Visitors stayed only long enough (15 to 30 minutes) to have one cup of tea and a little cake and to exchange information. Because of the brevity of the visit, they kept their hats and gloves on, as you can see in *Tea* (aka *Five O'Clock Tea*), which—through Cassatt's adept use of rich paints—captures magnificently the upper-class bourgeois setting and fine objects in the living room of Cassatt's Paris apartment (note the fancy striped wallpaper, the silver tea set, and the porcelain vase on the ornate mantel). Of particular interest here is Cassatt's use of interior lighting to highlight the figures.

Tea in the Cassatt household was obviously more than a "ceremony of innocence," as poet William Butler Yeats called it. "Take a cup of tea with [me] and discuss the art question," Cassatt wrote to collector Harris Whittemore and his bride, Justine, in the spring of 1893. Clearly, the talk was going to be about more than the weather.

As a hostess, Cassatt was something of a Martha Stewart, serving up tea or hot chocolate with clouds of whipped cream, and French cakes on fine china laid out on a heavy, embroidered cloth. As guests sipped their tea or reached for a smidgen of something sweet, they would admire the fine furnishings of Cassatt's Paris apartment—carved chairs on Turkish rugs, with splendid tapestries and paintings in gorgeous frames serving as backdrops, and statues and other art objects filling corners.

Sound Byte:

"She puts the welcoming smile of the 'at home.' She gives to us in Paris what none of our painters would be able to express—the joyous quietude, the tranquil goodwill of an interior."

—J.-K. HUYSMANS, critic, writing about Cassatt's
"Tea" paintings in the review *L'Art Moderne*, 1883

All of it would be lit, according to Cassatt friend May Alcott, by a great antique hanging lamp. Cassatt herself would cast a different kind of glow, presiding over her guests in a fetching outfit made of two shades of brown satin and rep (i.e., a ribbed, mix-blend fabric).

Cassatt never lost her fondness for this ritual. Years later, when her nieces would visit her at Beaufresne (her château at Mesnil-Théribus, 50 miles northwest of Paris), she would take them to Villotran, an

18th-century villa set in a park, where they would enjoy tea in a gazebo shaped like a temple to Venus—a ceremonial reminder of an age of innocence.

As with everything in Cassatt's domestic life, the tea ceremony became fodder for her professional life:

- **Most marketable image:** *Tea* (1879–80) was destined to be turned into a greeting card. Neither of the two women is the focus of this picture. One is seen in profile, while the other's face is half-obscured by her raised tea cup. The center of attention is a silver tea service, a family heirloom made for Cassatt's grandmother in 1813 and now in the collection of the Museum of Fine Arts in Boston.

- **Prettiest tea painting:** *Tea* (aka *The Cup of Tea*, 1880–81). The sitter is dressed in extraordinary pink fabric and white ruffles. Sipping tea never looked so charming. Monet would have approved of the colorful flowers behind her.

- **Most controversial tea painting:** *Lady at the Tea Table* (1883). Cassatt's portrait of her cousin Mary Dickinson Riddle and the handsome blue-and-white Chinese tea set that Riddle had given to the Cassatt family touched off…um…a tempest in a teapot. Mrs. Riddle is reputed to have been a great beauty, and her relatives thought the portrait did not do her justice. Indeed, the woman Cassatt portrays is no beauty but rather a cold, severe, even puritanical creature.

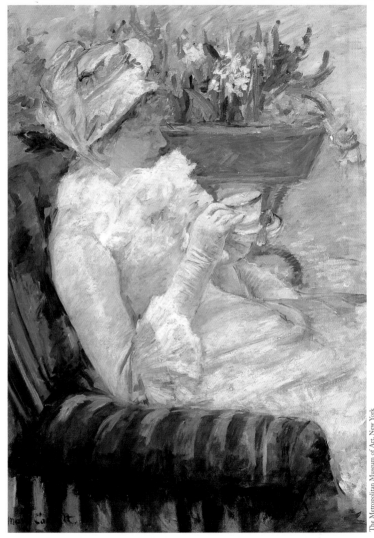

Up close, the painting offers a fascinating contrast between the looseness of Cassatt's furious brush strokes and the tightness of the subject's appearance—the drawn, set mouth; the long, grasping fingers. Not surprisingly, the portrait met with the approval of the persnickety Degas, who did not sentimentalize his subjects.

OPPOSITE
Tea (aka *The Cup of Tea*). c. 1879
37 3/4 x 26 3/4"
(92.4 x 65.4 cm)

"Hold on to your Monets. I am only sorry I did not urge you to buy more."
—MARY CASSATT, October 1883,
in a letter to her brother Alexander

Impressionist spats

Meanwhile, the Impressionists—once the Young Turks and now the aging lions—were drifting apart. (Their last show would be in 1886.) Over the years, Cassatt had remained true to the artistic and political ideals of the movement—no juries, no prizes—and had exhibited with the group at each of their shows from 1879 to 1886. (The one exception was the seventh show, of 1882, which she boycotted in support of Degas, who was in high dungeon over the refusal of Renoir and others to let newcomers into the group.)

Though they were one of art history's great success stories, the Impressionists were also a quarrelsome, jealous bunch, always jockeying for

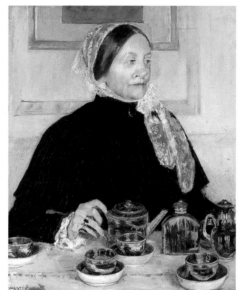

The Metropolitan Museum of Art, New York. Gift of the artist

position and sales, and fuming when one member, like the talented but struggling Alfred Sisley, broke with the group temporarily to submit works to the Salon in an attempt to make a sale. Cassatt's role in this volatile group was generally that of Degas' disciple, taking his part in disagreements with other core members, particularly Monet, whom Degas did not especially like. (Cassatt could, however, be independent-minded, siding with Monet and against Degas in the controversial Dreyfus Affair.)

The Lydia paintings

Cassatt's many portraits of her older sister Lydia are a poignant record of a woman dying young. At the same time, Cassatt went out of her way to portray a sister who truly relished her quiet, sedentary life:

- *Woman Reading in a Garden* (aka *Woman Reading: Portrait of Lydia Cassatt, the Artist's Sister*) is one of Cassatt's first *plein-air* paintings (i.e., painted outdoors). It is a profusion of pinks, blues, greens, and whites, and shows beautifully the effects of sunlight on Lydia. The work was shown in the Impressionist Exhibition of 1880.

- In *Lydia Seated at an Embroidery Frame* (aka *Lydia at a Tapestry Loom*), it is hard to see where Lydia's floral print dress leaves off and the brightly colored armchair begins, so much was the artist caught up in color and brush strokes. The work was painted during the last year of Lydia's life.

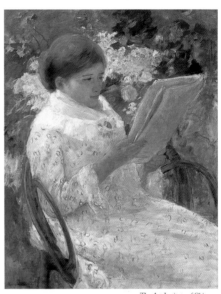

The Art Institute of Chicago

Woman Reading in a Garden
1878–79. 37 x 27"
(90 x 65 cm)

67

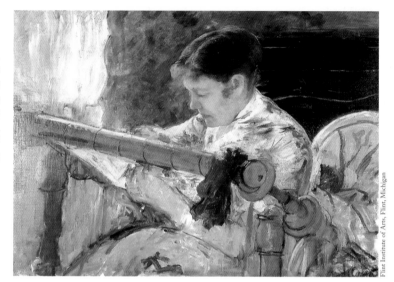

Lydia Seated at an Embroidery Frame (aka *Lydia at a Tapestry Loom*)
1880–81
26³⁄₄ x 37¹⁄₂"
(65.5 x 92 cm)

Flint Institute of Arts, Flint, Michigan

- *Lydia Seated in the Garden with a Dog in Her Lap* places Cassatt's sister, knitting, with her back to us, amid a tangle of flowers.

- *The Garden* (aka *Lydia Crocheting in the Garden at Marly*) presents us with a Lydia who looks as ghostly as her pink-and-white lace bonnet.

- *Autumn* (1880) depicts a pale and drawn Lydia, swathed in thick earth colors as if to guard against autumn's chill. It is a touching study of a woman in the fall of her life.

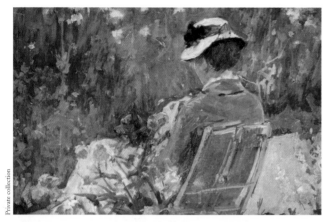

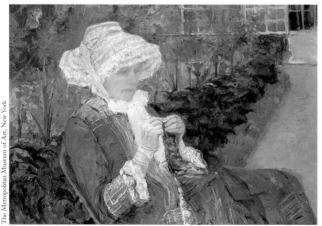

LEFT
Lydia Seated in the Garden with a Dog in Her Lap. c. 1880
11 1/8 x 16 3/4" (27.3 x 40.6 cm)

BELOW LEFT
The Garden (aka *Lydia Crocheting in the Garden at Marly*). 1880. 27 x 37"
(66 x 94 cm)

BELOW RIGHT
Autumn. 1880. 38 x 26 1/2"
(93 x 65 cm)

Profound sorrow

Lydia Cassatt died on November 7, 1882, leaving her sister inconsolable. Months later, during a visit from the United States, Alexander's wife, Lois, observed that Cassatt could scarcely bring herself to lift a paintbrush. It was months before she was able to take up painting again. Fortunately, she found the strength to do so, for much of her best work remained to be done. Lydia's death, however, moved Cassatt deeply and would lead her to move away from the joys and freedom of Impressionism toward a more severe, restrained style. One of the last works to reflect her interest in sunlight on the canvas was *Susan on a Balcony Holding a Dog* (aka *Young Girl at a Window*) in which she incorporated the city of Paris into a painting, something she rarely did. Two examples of the new, more serious paintings are *Lady at the Tea Table* (see page 66) and *Portrait of Alexander Cassatt and His Son Robert Kelso* (see page 72).

The family—and children in particular because of the joy they brought to her in this time of grief over the loss of Lydia—became even more important to her. *Children Playing on the Beach* exemplifies Cassatt's ability to portray children on their own sensuous, unsentimental terms. The little girl in the foreground is seen playing contentedly and intently with her pail and shovel. There are no big saucer eyes, no pleading looks to arouse our sympathy. And yet her peachy cheeks, dimpled knees and

Susan on a Balcony Holding a Dog (aka *Young Girl at a Window*)
c. 1883
41 x 26 ½"
(100.3 x 64.7 cm)

Alexander Cassatt and His Son Robert. 1884–85. 39 x 32" (95.5 x 78.4 cm)

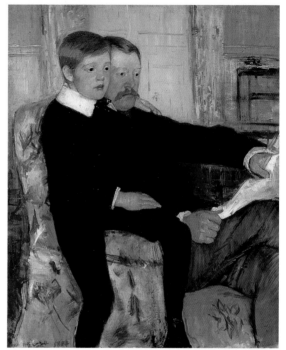

elbows, and curling lashes are as engaging as the creamy sand and the misty sea in the distance. As in other Cassatt works, the artist omits fleshing out the background. The little girl's playmate—perhaps her sister, since they wear matching dresses and pinafores—has indistinct

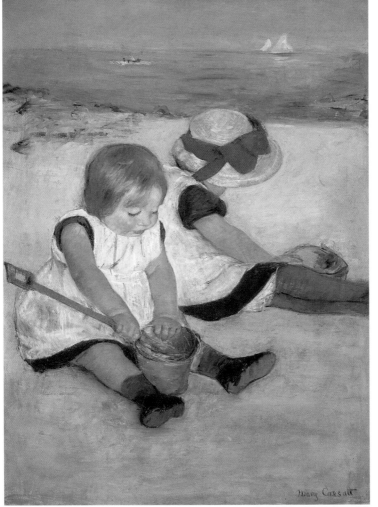

Children Playing on the Beach (aka *Two Children at the Seashore*) 1884. 40 x 30¼" (97.6 x 74 cm)

National Gallery of Art, Washington, D.C.

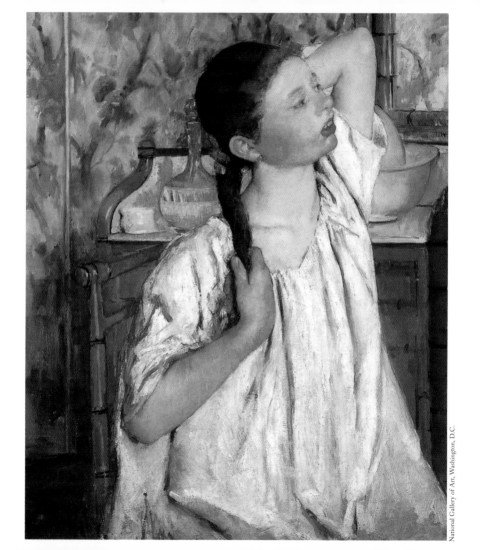

hands and an equally undefined pail. The sailboats on the horizon are just a few feathery strokes of white.

Hilarious episode

One of the more comical interchanges between Degas and Cassatt occurred in late 1885. It seems that one day, in her assessment of a well-known painter whom they both knew, Cassatt said, "He lacks style." Degas looked at her condescendingly, as if to say, "And what would *you*, a woman, know about style?" This angered Cassatt, who immediately hired an ugly model, a kind of servant-girl type, and had her pose in a robe next to her dressing table, her left hand at the nape of her neck holding her hair while she combed it with her right hand, just before going to bed. Cassatt captured the model in profile, her mouth hanging wide open, her expression weary and stupid. When Degas saw the painting, entitled *Girl Arranging Her Hair*, he was overwhelmed by it and wrote to Cassatt, "What drawing! What style!"

It had been Cassatt's purpose to demonstrate that, regardless of the beauty or ugliness of a subject, it was the artist's talent for drawing, composition, and color that made the difference. How did Degas respond? He bought the painting and owned it for the rest of his life, after which it was purchased by Louisine Havemeyer.

New directions

As the decade came to a close, it was remarkable that Cassatt had any time for work, what with all the Impressionist infighting, the personal heartaches in her life, the comings and goings of family, as well as some minor mishaps (e.g., a riding accident in 1889 that had left her temporarily sidelined with a broken leg; a carriage accident in 1890 in which she had been slightly injured). But she found the strength and the courage to push her art in three new directions: as a **printmaker** chronicling the private and public moments in the daily lives of women; as a **muralist** celebrating the ideal of modern woman; and, perhaps most famously, as a painter of the special bond between **mothers and children**.

Moving into print

Anti-Impressionist sentiments dogged the rebel artists in a variety of ways. In 1891, the American-born Cassatt and the West Indies–born Pissarro were shut out of the third exposition of the reformed *Société des Peintres-Graveurs Français* (the Society of French Painters-Engravers), which had decided that only French-born artists could be members. The pair responded by staging an exhibit in April 1891 alongside the Society's show at the gallery of Durand-Ruel. Cassatt displayed a series of works that many experts consider to be the perfect expression of her interests and personality.

The Ten (1890–91)

The works, affectionately known as *The Ten,* form a series of ten color prints that depict scenes from women's daily lives. The prints would come to be viewed as a high mark in Cassatt's career and are noteworthy for her rare portrayal of the nude figure. (Recall: She had long been interested in printmaking, having studied the process with Carlo Raimondi in Parma and made etchings of nudes under the supervision of Degas. Moreover, she had joined Degas and Pissarro in working on prints for the ill-fated journal *Day and Night.*)

What got Cassatt thinking about printmaking in a new way was a blockbuster show at the École des Beaux-Arts in Paris in 1890, an exhibit of late 18th- and early 19th-century woodcuts, or woodblock

FYI: Going postal in the 19th century—In this age of e-mail, we sometimes forget that letter writing was an essential part of life in Victorian times. Often it was the sole means of communicating with loved ones at a distance. So vital was the role of letter writing in a woman's life that when Cassatt created *The Ten,* one of the images she chose to depict was that of a woman sealing an envelope at a desk. The desk in *The Letter* was actually Cassatt's.

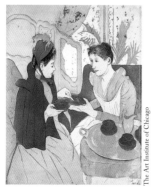

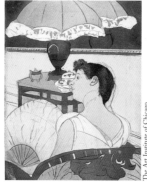

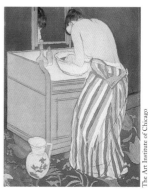

TOP LEFT
The Visit (aka *Afternoon Tea Party*). 1890–91. Drypoint, softground etching, and aquatint on cream laid paper
14 ½ x 10 ¾"
(34.8 x 26.3 cm)

TOP CENTER
The Lamp. 1890–91
Drypoint, softground etching, and aquatint on cream laid paper
13 ⅓ x 10 ¼"
(32.3 x 25.2 cm)

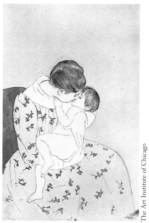

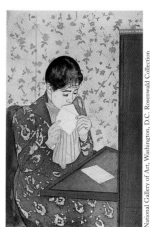

prints, by Japanese masters of the *ukiyo-e* (i.e., pictures of the floating world). Ukiyo-e was the dominant Japanese art from the 17th to the 19th centuries. It was characterized by flat decorative color and expressive patterns, and its favorite subjects included scenes of prostitutes, Kabuki actors, bathhouse girls, and scenes of transient everyday life with its ever-shifting fashions. Prominent ukiyo-e artists included **Ando Hiroshige** (1797–1858) and **Kitagawa Utamaro** (1753–1806).

The 1890 Japanese print show was one of the cultural benefits that occurred when Japan opened up to the West in the second half of the 19th century. This had sparked a mania in France for all things Japanese, which could be seen in everything from the theatrical posters of Toulouse-Lautrec, with their flat, vibrant colors, to the musical compositions of **Claude Debussy** (1862–1918) and **Gabriel Fauré** (1845–1924), many of which use the pentatonic, or five-note, scale characteristic of Eastern music.

Cassatt was thunderstruck. Why was she so drawn to this exhibit? Among the works on display were woodblock prints and illustrated books by Kitagawa Utamaro, celebrated for his works exploring the special bond between mothers and children as well as for his scenes of courtesans bathing, playing musical instruments, and grooming themselves (as in *An Artist Surrounded by Geishas*).

OPPOSITE

TOP RIGHT
The Bath (aka *Woman Bathing*) 1890–91. Drypoint, softground etching and aquatint on cream laid paper 15 x 10¾" (36.8 x 26.3 cm)

BOTTOM LEFT
The Kiss (aka *Mother's Kiss*) 1890–91. Drypoint, softground etching and aquatint on cream laid paper 14½ x 9½" (34.9 x 22.9 cm)

BOTTOM RIGHT
The Letter. 1890–91. Drypoint, softground etching and aquatint on cream laid paper 13⁹⁄₁₆ x 8⁷⁄₈" (36.6 x 26.6 cm)

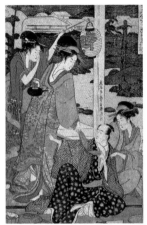

British Library, London. Art Resource, NY

In Utamaro Cassatt saw a kindred spirit, and she began collecting his works, which she assembled at Beaufresne. Inspired by the master, Cassatt decided to create her own version of Utamaro's "floating world."

Cassatt maintained that there were only two paths open to a painter—"the broad and easy one, and the narrow and hard one." For the demanding Cassatt, there was really only one way. From 8:00 A.M. until daylight gave out, she toiled with Monsieur Leroy—a printer she had brought in on the project to provide her with technical assistance—in a pavilion over a dam near her Paris apartment. To achieve the two-dimensional effect of Japanese prints, with their flat blocks of color and striped and floral patterns, Cassatt used the two basic mediums/techniques of **aquatint** and **drypoint** (see page 82).

Sound Byte:
"If you would like, you could come and dine here with us and afterwards we could go to see the Japanese prints at the Beaux-Arts. Seriously, you must not miss that. You who want to make color prints, you couldn't dream of anything more beautiful. I dream of it and don't think of anything else but color on copper."

—MARY CASSATT, c. 1890, writing to Berthe Morisot

"The result is admirable, as beautiful as Japanese work."

—CAMILLE PISSARRO, artist, writing to his artist-son Lucien
in 1891 about Cassatt's series of ten color prints

The series juxtaposes parallel events in the lives of two different women, a self-absorbed redhead and a maternal brunette. The curve of the redhead's nude back in *The Bath* matches the curve of the nude infant in the arms of the brunette in *The Kiss*. While the redhead entertains evening guests in *The Lamp*, the brunette attends to correspondence in *The Letter*. The two women finally meet in *The Visit*, the only one of the ten prints in which they come together. (The brunette seems a bit snooty as she takes a cookie from a plate offered by the redhead, who is the hostess.) But are they really two different women, or two faces of womanhood?

Despite the importance of the series, the critical (and popular) response at the time was mixed. While some biographers point to the success of the print show, Pissarro called the reaction "mostly hostile." And though the prints were shown in New York later in 1891, they attracted only a handful of American buyers, which disappointed Cassatt.

OPPOSITE
Kitagawa Utamaro
An Artist Surrounded by Geishas at a Tea Party in the Yoshiwara
c. 1790–1800
Color woodblock print

THE ABCs OF PRINTMAKING

In printmaking, pictures or designs can be made in various ways:

- A **woodcut** is a relief print made by cutting an image into a block of wood, inking the raised uncut surface, and rubbing or pressing paper over it.

- **Engraving, etching, aquatint,** and **drypoint** are *intaglio processes* in which an image is either bitten with acid onto a metal plate (engraving) or incised with a pointed tool onto the plate (drypoint). Ink is then rubbed into the grooves. While the processes differ in how the grooves are made, they all use a press to print the image onto paper. With **aquatint,** the artist dusts the plate with resin and then immerses it in an acid bath to simulate the quality of washes of ink and watercolors. With **drypoint,** the artist draws directly onto a metal plate—in this case, copper—using an etching needle. The etching process throws up ridges of metal residue, called *burr*. When the plate is inked and printed, the burr yields a rich, velvety tone. Cassatt liked drypoint, because one must be exceedingly good to draw on copper. Or as she put it: "You can't cheat."

- **Lithography** and **silkscreen** are *planographic techniques* (i.e., using flat surfaces). In lithography, an image is drawn on a smooth stone or metal plate with a greasy crayon. The surface is covered with water so that the ink adheres only to the greasy drawing. A press is rolled over the surface to transfer the image onto paper. In silkscreen, or *serigraph*, a stencil is attached to a silkscreen, and ink is forced through the mesh with a squeegee. The ink prints through the open areas onto the paper underneath.

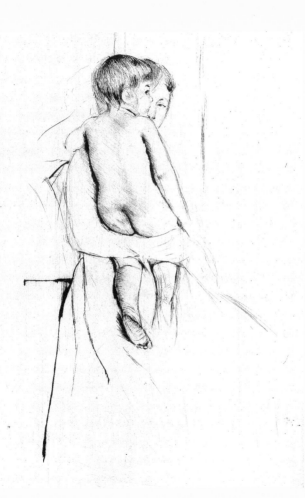

Baby's Back. 1889
Drypoint, third
state, 9 3/16 x 6 7/16"

The Library of Congress,
Washington, DC

Sound Byte:

"This back, did you draw this? I cannot admit a woman can draw like that."

—EDGAR DEGAS, to Cassatt on seeing her
seminude redhead at her toilette

Beaufresne

By the time of her father's death, Mary was already financially independent from the sale of her paintings. But an inheritance from her father gave her even greater financial stability, so in 1893 she decided to buy an 18th-century country estate located on 45 acres in the small town of Le Mesnil-Théribus, not far from Paris. The three-story, pinkish-red brick house was called Château de Beaufresne (Château of the Beautiful Ash Trees) and for years it would be a source of joy and quiet refuge for the artist.

The new Eve

Beaufresne came along at just the right time. The World's Fair of 1893 was being planned for Chicago, and one of the buildings to be erected there was to be called the Woman's Building. It would house the celebration of women's contributions to civilization, from primitive times to the present.

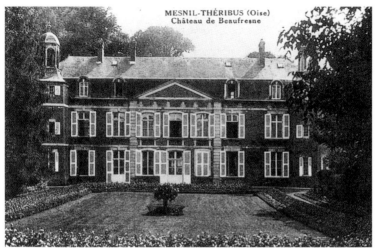

MESNIL-THÉRIBUS (Oise)
Château de Beaufresne

Château de
Beaufresne
c. 1895

The wealthy Chicago philanthropist Bertha Palmer was president of the fair's Board of Lady Managers. She had seen Cassatt's work and admired it, so she offered Mary a commission to create *Modern Woman*, one of two major murals that would be installed high above the two tympana above the central court of the Woman's Building.

Mary MacMonnies, another American artist in France, was commissioned to create the second of the two murals. Hers was to spotlight *Primitive Woman*, which she did in the static style of her teacher **Pierre Puvis de Chavannes** (1824–1898), renowned for his panoramic works of friezelike figures in pastoral settings.

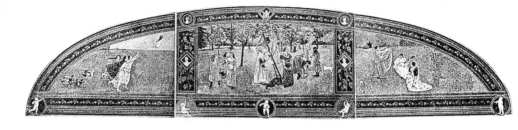

Modern Woman
1892–93
17' 4" x 72' 2"
(42.7 x 176.8 m)
Mural decoration
for the Woman's
Building, World's
Columbian
Exposition,
Chicago, 1893
Location
unknown

Unlike MacMonnies, Cassatt was untrained as a muralist, but decided to take the plunge anyway. She was eager to tackle new challenges, but also to create interest in her work in America. Degas and Pissarro advised against it, since mural painting seemed like too much of a departure for her. Degas, as usual, was outraged when Cassatt refused to listen to him. Thus began one of her most intriguing but not entirely successful works. Though the mural is now lost (and probably destroyed), we do have photographs of it.

Cassatt's inexperience as a muralist showed. While painting the mural (14 by 58 feet), she seemed not to realize that it would be installed high above the entrance to the central court of the Woman's Building. As a result, the images she painted were so tiny that, once installed, they could barely be seen from down below on the ground floor.

Nonetheless, the images in the three segments of the mural are fascinating. In the left panel, a group of young girls chases an infant, who

86

flies away from them. The child is a symbol of the fame that young girls should be free to pursue in their lives. In the central section, a group of women dressed in flowing 19th-century dresses plucks the fruits of knowledge and science from a tree. They are the new Eves, not banished from Eden for eating an apple but delivered into a brilliant life in which they should be encouraged to explore all opportunities and goals. The right segment shows women dancing and playing the banjo, an instrument popular with young women in the 19th century. They evoke Utamaro's graceful scenes of Japanese women playing the three-stringed samisen.

What does this mural tell us about Cassatt? That she loved the arts and learning, yes, but that she also thought women, while keeping their private lives private, should not suppress their talents or their work. Like the women in her mural, Cassatt pursued the child of fortune, a modern (and daring) notion in her time.

Mother and child reunion

It is no small irony that the artist who was a true "career woman" before the phrase was invented should earn her greatest fame as a painter of mothers and children.

Why did Cassatt turn to this subject? No one knows, since she offered no explanation of it. Experts suggest a variety of reasons: that Degas

encouraged it; that the birth of Gardner and Jennie's first child, Joseph Gardner Cassatt III, in 1886, enabled her to see the maternal bond in a new light; that it was an influence from the early days when she studied the Old Masters' treatments of the Madonna and Christ Child; and so forth. Then, too, there was her close relationship with her mother, made even closer by the deaths of her father and sister.

Was it perhaps a way for her to experience motherhood? At one point, she observed that "a woman's vocation in life is to bear children." Was it the regret of a woman who recognized that she had deliberately closed herself off from some of life's possibilities in order to pursue others, or the momentary nostalgia of an elderly woman for a past that might have been?

Sound Byte:
"My mistake was in devoting myself to art, instead of having children."
—MARY CASSATT, 1924, to Adolphe Borie,
a young painter from Philadelphia

Whatever her attitude toward motherhood, the ambitious, single-minded Cassatt seems to have wasted little sleep or tears over matrimony. She was apparently once briefly engaged (in October 1868) to Carsten Haldeman, the brother of Eliza Haldeman, her classmate from the Pennsylvania Academy of the Fine Arts. This may, of course, have

been nothing more than a joke instigated by their having seen a wedding veil in a shop window.

Almost 40 years later, in 1906, she met the American banker **James Stillman**, with whom she formed a personal and professional relationship, although she would also tell friends that she had nipped in the bud any romantic notion he might have had. As for Degas, whom some view as the great male love of her life, the haughty Cassatt dismissed such a notion in her later years with "What? That common little man? What a repulsive idea." (For his part, the finicky Degas told art editor Forbes Watson that "I would have married her, but I could never have made love to her.")

This is hardly the romantic history of a woman eager to be a wife and mother. And yet, it may be the perfect background for a painter of mothers and children, giving Cassatt and her works an objectivity about the subject that she might not otherwise have possessed. After all, she didn't use just actual mothers and children in these works. She also paired models and neighborhood children for the effects she wanted. The fresh, charming *Young Mother* (on the next page) is a splendid example of the latter, with the mother intent on her needlework and her little girl gazing frankly at the viewer.

Children are sometimes more central to her canvases than are mothers. Cassatt's compositions were influenced in part by her studies of

Renaissance art depicting Madonna and Child scenes, as in Luca della Robbia's sculpted *Madonna and Child in a Niche* (c. 1440–60). Here, the Christ Child is the central figure, not Mary, his mother. And yet he clings to her as she caresses and reassures him.

Young Mother (aka *Young Mother Sewing*). 1900
37 3/4 x 30"
(92.4 x 73.7 cm)

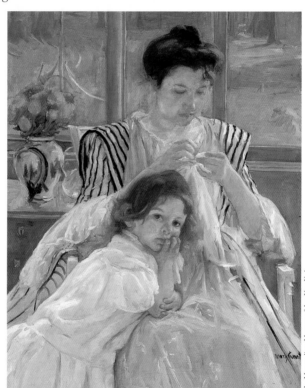

A major work from 1893–94, *The Boating Party*, combines three crucial elements found in Cassatt's work over the years:

- storytelling, key to her earliest paintings;

- the mother-and-child theme;

- flat blocks of bold colors, which evoke her enthusiasm for Japanese prints.

The result is an intriguing narrative painting. The oarsman's midnight-blue outfit ties him to the sea and all the yearning and adventure it suggests. The yellow-green of the boat's interior and the oar and the moss-green of the sail serve as an anchor to the woman and child, who wear pale-green hats. The oar also serves as a barrier between the man and the woman. They do not seem to be husband and wife, and yet she looks tenderly, almost expectantly at him. The child, on the other hand, looks quizzical, even fearful. The man's face is half-hidden but he appears to meet the woman's gaze.

Luca della Robbia. *Madonna and Child in a Niche*. c. 1440–60. Glazed terracotta Height without frame 20.4" (50 cm)

Florence, Orsanmichele. Scala/Art Resource, NY

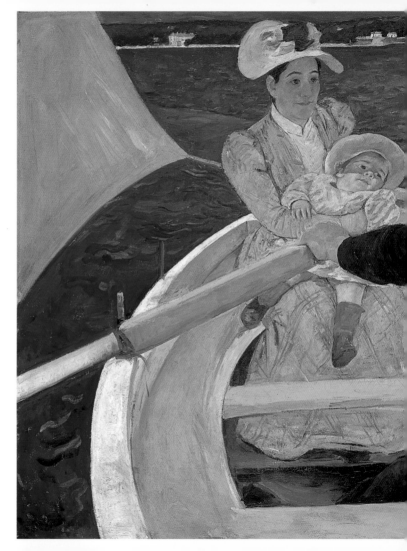

The Boating Party
1893–94
35 ½ x 46 ⅛"
(0.2 x 117.1 cm)

Perhaps they are interested in one another. Perhaps she is merely minding the child. We don't know. But it's fun guessing.

Summertime, from the same year, shows yet another fanciful moment on the water shared by a mother and daughter. This theme would

RIGHT
Summertime
1894
41 ⅛ x 33 ¼"
(100.7 x 81.3 cm)

OPPOSITE LEFT
Maternal Kiss
1897. Pastel on
paper. 22 x 18 ¼"
(53.9 x 44.7 cm)

OPPOSITE RIGHT
*Portrait of Mrs.
Havemeyer and
Her Daughter
Electra.* 1895
Pastel on paper
24 ¾ x 31 ¾"
(61 x 77.5 cm)

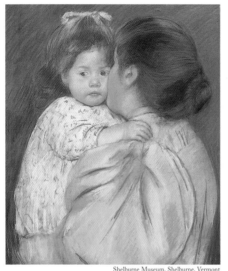

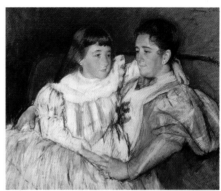

be employed over and over for the next few years and would bring Cassatt enormous popular success—so much so that her dealer, Durand-Ruel, begged her to paint faster so that they could keep up with the demand. In 1895, she even painted her dear friend Louisine, accompanied by her daughter, in *Portrait of Mrs. Havemeyer and Her Daughter Electra*. Examples of the mother-and-daughter works include *Maternal Kiss, Breakfast in Bed,* and *Young Mother*. She even captured the joy of little children alone, unaccompanied by their parents, as in the 1896 portrait of her favorite niece, *Ellen Mary Cassatt in a White*

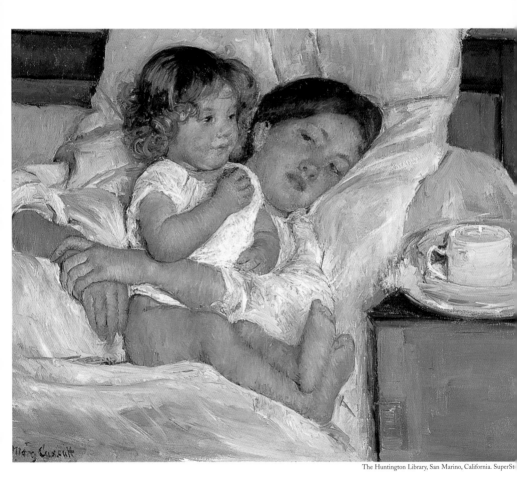

Coat (it was Ellen Mary who inherited Beaufresne), and in the 1901 portrait of *Sara in a Green Bonnet* (see page 100).

Cassatt captures the same tenderness in *Mother and Child*. (This is the work that Degas described sarcastically as "the Infant Jesus and his English nurse.") The child's stance, with one leg bent and the other hip thrust out, is reminiscent of the Renaissance Christ Child, as is his nudity.

Child nudity plays a big part in a number of these paintings, including *The Caress* and *Two Mothers and Their Nude Children in a Boat*. Yet these works are touching, not titillating; sensuous, not sensual. For a woman who has always esteemed the nude figure and the masters who had painted it—Courbet, Manet, Degas—Cassatt finds in her mother and child reunions a way to explore the nude at its most innocent.

OPPOSITE
Breakfast in Bed
1897. 26 ½ x 30"
(65 x 73.6 cm)

Sound Byte:
"One might almost speak of Cassatt's lust for baby flesh, for the touch, smell and feel—intimate touching plays an important role here—of plump, naked, smooth-skinned bodies, a desire kept carefully in control by formal strategies and a certain emotional diffidence."
—LINDA NOCHLIN, critic, *Representing Women*, 1999

Show me the Monet!

If Cassatt had not been a great artist, she would have made a first-rate art dealer. Indeed, her taste and expertise made her a first-rate adviser.

Thanks to sister Mary, Alexander Cassatt—president of the Pennsylvania Railroad and a man said by some to be worth $50 million at that time—built an excellent art collection. But he was only one of several wealthy American patrons to benefit from Mary's guidance. As Cassatt's health problems—diabetes, rheumatism, and, most poignantly, failing eyesight due to persistent cataract troubles—made painting increasingly difficult, she developed at the turn of the century a second vocation as an art consultant. And we are the richer for it.

Why? Because many of the works owned by the captains of American industry have found their way into the collections of American museums. The best example of this is the Havemeyer Collection, much of which is now in The Metropolitan Museum of Art. Henry and Louisine Havemeyer created one of the 19th century's greatest art collections—more than 500 paintings, drawings, and watercolors, including 65 Degases, 41 Courbets, 30 Monets, 25 Corots, 25 Manets, 17 Cassatts, 13 Cézannes, and 6 Pissarros. Today this group alone would be worth upward of $1 billion.

In bringing her colleagues together with collectors, Cassatt's purpose was twofold. Yes, she wanted the Impressionists to make inroads

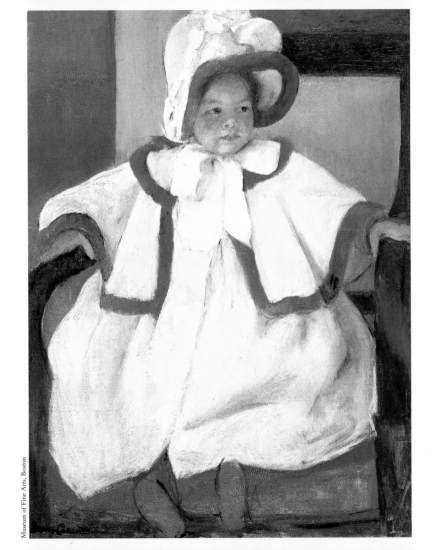

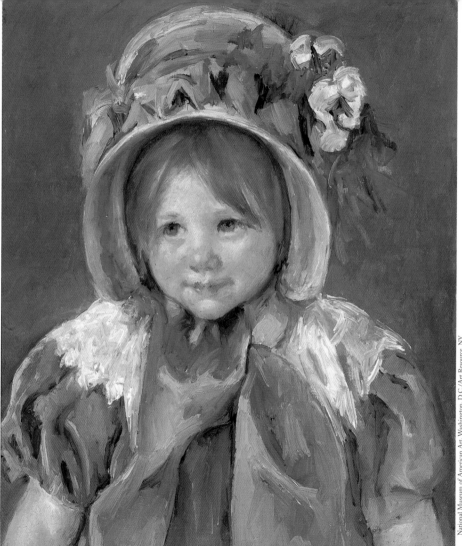

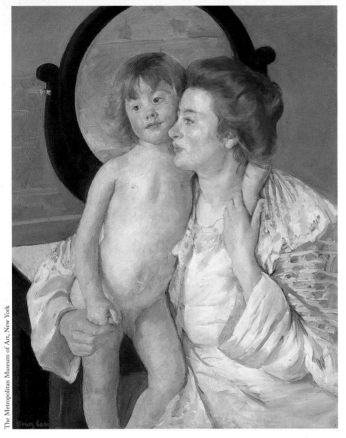

LEFT
*Mother and Child
(The Oval Mirror)*
c. 1899
33 1/4 x 26 3/4"
(81.6 x 65.7 cm)

OPPOSITE
*Sara in a Green
Bonnet.* c. 1901

in the American market, herself included. But even though she re-
turned to the United States only twice after 1874, this "frankly Amer-
ican" woman also wanted her homeland to be steeped in art old and

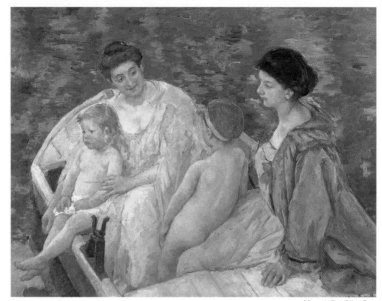

Musée du Petit Palais, Paris

new. For this reason, too, Cassatt was always willing to host American art students and struggling artists or hook them up with artists like Pissarro.

Perhaps the most intriguing of Cassatt's art consulting "jobs" was her relationship with American investment banker James Stillman, who became attracted to her soon after they met in the spring of 1906.

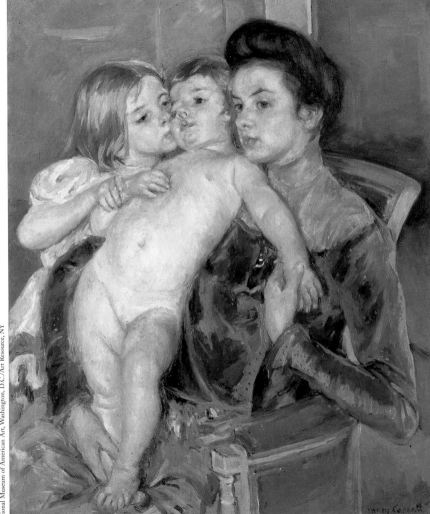

mary Cassatt

Stillman was like something out of an Edith Wharton novel (he even knew Wharton!), brilliantly successful in business but cold and ruthless in his private life. (He dumped his wife after 23 years of marriage, then let it be known that she had mental problems.)

But he did not frighten the formidable Cassatt, who set about educating him artistically even as she fended him off romantically. Under her tutelage, Stillman became a fine collector of Old Masters and one of the foremost collectors of Cassatt's work.

Shoulder to shoulder

Meanwhile, Cassatt was drawn into the burgeoning suffrage movement, thanks to her old pal Louisine Havemeyer. At Havemeyer's urging, she took part in an exhibit in April 1915 in New York to benefit the cause. Also in the show were works by Old Masters and Degas. (Cassatt, of course, didn't tell the chauvinistic Degas the rea-

Mary Cassatt
1913

> **FYI:** When Cassatt returned to the States in 1898 with her little Belgian griffon for her first visit in more than 20 years, an American newspaper could say only that she was the sister of the president of the Pennsylvania Railroad and had the smallest dog in the world!

son for the show, thereby making the event all the more delicious for her.)

But Cassatt was no early Gloria Steinem. For one thing, she believed that only white women with at least one American-born parent should be allowed to vote in America, once again revealing that she was a creature of her time and class.

And while she was sympathetic to working women—she saw herself as a working woman—she was ambivalent about women's ability to govern themselves. In a letter to Havemeyer dated December 3, 1912, she railed against her sister-in-law Jennie's comments about wanting to spank a militant suffragist. But then in the next breath she said Jennie's insolent behavior was the result of her (late) husband's no longer being there to keep her in line.

Sound Byte:

"Cassatt's art expresses her notions of feminism through her portrayal of women as contemplative and spiritual beings as opposed to decorative objects."

—ERICA H. HIRSHLER, associate curator of
American paintings at the Museum of Fine Arts, Boston

And yet on balance, we see Cassatt as a dedicated feminist. She rightly predicted that World War I (1914–18), against which she raged and which she saw largely as the result of male aggression, would bring about a new world order in which women would come to the fore. In 1920, two years after the war had ended, the 19th Amendment to the U.S. Constitution gave American women the right to vote.

"The Dream of Done"

"We die by inches," Cassatt once said. Fewer words better describe her sad decline and end.

In 1915, she abandoned her art, plagued by a variety of ailments but most especially by her virtual blindness, caused by cataracts, which several operations had failed to alleviate. (Blindness was yet another experience she shared with Degas.)

Sound Byte:
"How we try for happiness, poor things, and how we don't find it. The best cure is hard work if only one has the health for it."

—MARY CASSATT, in a letter to
"Louie" (Louisine Havemeyer)

Still, she was as feisty as ever. She went out in her car (with a chauffeur, of course) and hosted her nieces and nephews. She prompted Degas' niece, Jeanne Fèvre, to care for her aging uncle and kept up her interest in auctions.

But there was the sense that Cassatt was just killing time. She was a woman haunted by the losses in her life—Alexander died in 1906, Gardner in 1911, and Degas in 1917.

Practically everything and everyone she loved was gone. In a November 1920 letter to Louisine Havemeyer, she quoted some lines from Elizabeth Barrett Browning's poem "The Lost Bower": "I have lost the dream of doing and the other dream of done."

Edgar Degas. 1908

Those who had not gone before her were sorely tested. A couple of years before her death, Cassatt had a tiff with Havemeyer over prints that Cassatt had sent to The Metropolitan Museum of Art. (Apparently, the plates had been printed before.) Cassatt stopped speaking to her friend of several decades, claiming that Havemeyer "is nothing anymore."

Journalists who made the pilgrimage to Beaufresne and Cassatt's Paris apartment described a blind, bitter old woman, a kind of female King Lear.

Mary Cassatt. 1925

But to those who loved her and who benefited from her knowledge and talent, Cassatt remained a woman of great passion.

When Mary Stevenson Cassatt died at Beaufresne on June 14, 1926, at age 83, her friends and loved ones remembered not the struggles of a driven woman, but the gifts of a luminous star.

What was she like?

What was Mary Cassatt like? In a word: Difficult. You always knew where you stood with her. A woman of fierce opinions, she adored the novels of Jane Austen but despised those of Edith Wharton. She revered the Old Masters, and though she declared herself a modern painter, she detested much of modern art (e.g., she called Henri Matisse "bad news" and described the home of writer Gertrude Stein, whose Paris apartment was a mecca for the likes of Matisse and Pablo Picasso, as a place filled with "dreadful people" and "dreadful paintings").

Even people and things that had long been regarded with affection failed to meet with her approval. She dismissed her Impressionist colleague Claude Monet's

water-lily paintings as "glorified wallpaper." And when portrait painter John Singer Sargent—arguably one of the most charming and self-effacing of men—came to call, well, he did not even get a foot in the door.

There was nothing subtle or discreet about her likes and dislikes. She was passionate about virtually everything: What she loved, she adored—and what she hated, she despised. Cassatt could be savagely witty or just plain savage in expressing her opinions—a trait she shared with her pal Degas. (It was Degas who felt the need to sneer at the funeral of his onetime good friend, the painter Gustave Moreau, who had captured him so lovingly in the drawing *Full-Length Portrait of Degas in Florence* (1858): "Moreau was one of those men who always begin by pulling in their feet for fear someone might walk on them.")

Cassatt's passionate personality is revealed in her letters, which focus on friends and family, the weather, a wedding, travel, and petty troubles. When she wrote about world news, it was mostly to comment on its effect upon her own little corner of the world.

Still, the letters are chock-full of revealing tidbits:

- Many give details about the art market, since Cassatt used her correspondence to help shape her friends' art collections. These show her to be a woman of exquisite taste, albeit somewhat limited, but with a strong business sense.

- Though 19th-century ladies were advised by the Emily Posts of their day never to write in haste, the impetuous Cassatt dashed letters off while hurrying for a carriage or a train or rushing to meet the post. Her handwriting suggests a woman of great confidence and industry. It is so bold and horizontal that the crosses on the "t's" extend over words like little awnings.

- Despite her strong opinions, Cassatt could be surprisingly humble, writing that she was unworthy of her friends' generosity. And she could be effusive in her admiration, sometimes signing her letters "lots and lots of love to all yours, ever affectionately."

OPPOSITE
Mary Cassatt
1914

Sound Byte:
"I like to see her as determined, focused, highly disciplined. Maybe that translated into a person that didn't accept less than a very high standard."
—ELLIOT BOSTWICK DAVIS, great-great granddaughter of
Louisine Havemeyer and assistant curator of American art
at The Metropolitan Museum of Art

Mondo Cassatt

In her last years, Cassatt was lionized—and sentimentalized—as a painter of mothers and children, most notably by her biographer